ACROSS THE AEGEAN

AN ARTIST'S JOURNEY FROM ATHENS TO ISTANBUL

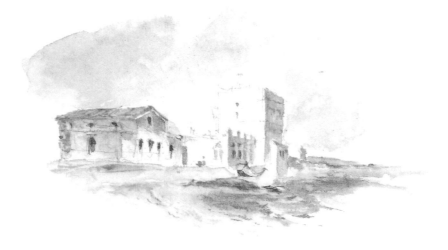

MARLENE MCLOUGHLIN

CHRONICLE BOOKS

SAN FRANCISCO

Printed in Hong Kong.

Library of Congress Cataloging-in-Publication Data available.

Cover design: Brenda Rae Eno
Book design: Brenda Rae Eno and Joyce Kuchar
Cover illustration: Marlene McLoughlin

ISBN 0-8118-0862-9

Distributed in Canada by Raincoast Books,
8680 Cambie Street
Vancouver BC V6P 6M9

10 9 8 7 6 5 4 3 2 1

Chronicle Books
275 Fifth Street
San Francisco, CA 94103

Once out of nature I shall never take
My bodily form from any natural thing,
But such a form as Grecian goldsmiths make
Of hammered gold and gold enamelling
To keep a drowsy Emperor awake;
Or set upon a golden bough to sing
To lords and ladies of Byzantium
Of what is past, or passing, or to come.

W.B. YEATS
"SAILING TO BYZANTIUM

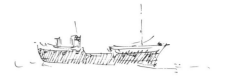

HAVING SPENT A YEAR PAINTING IN ITALY, MY CURIOSITY DREW ME TO THE EAST. I WANTED TO EXPLORE GREECE TO SEE WHAT HAD INSPIRED ROME, AND THEN TO CONTINUE FARTHER TO ISTANBUL, A NAME THAT HAD FASCINATED ME SINCE CHILDHOOD. I WANTED TO SEE THE EDGES OF THE COUNTRIES, THE HARBORS, THE INLETS, THE FOLDS OF THE LAND AS IT FALLS DOWN TO THE SEA.

I STARTED BY SPENDING SEVERAL DAYS IN ATHENS AND IT WAS WITH A SENSE OF EXHILARATION AND GRATITUDE THAT I LEFT THAT BLACKENED AND UNGRACIOUS CITY. I BOARDED A FERRY FOR AN ISLAND IN THE CYCLADES. THE MAINLAND, UMBER IN THE FLAT LIGHT OF EARLY AFTERNOON, GRADUALLY FELL OUT OF SIGHT THE WHITE FERRY ON THE INDIGO SEA BECAME THE KNOWN WORLD UNTIL, AT SUNSET, WE APPROACHED A SALMON, GOLD, SIENNA, AND HELIOTROPE WASH OF COLOR ON THE HORIZON: NAXOS, MY BASE FOR THE INITIAL LEG OF MY JOURNEY. EVERY MORNING I HAD BREAKFAST LOOKING OUT OVER THE PROFOUND BLUENESS OF THE SEA AND WATCHED AS THE SUMMER WIND CAME DOWN FROM THE NORTH, TURNING THE TIDELESS LAKE OF THE SAPPHIRE AND TURQUOISE AEGEAN INTO A REAL OCEAN OF WAVES AND WHITECAPS. AND THEN

THE LIGHT: EVEN THROUGH DARK GLASSES, THE LIGHT REFLECTING OFF THE PAGES OF MY SKETCHBOOK WAS STUNNINGLY, DAZZLINGLY INTENSE.

AS SEDUCTIVE AS THE ISLANDS WERE, THE PELOPONNESE BECAME A MORE LASTING AND COMPLEX LOVE, TO WHICH I RETURNED AGAIN AND AGAIN, USING NAFPLIO, THE FIRST CAPITAL OF THE REPUBLIC OF GREECE, AS A BASE. I HAD EXPECTED A COUNTRY OF CLASSICAL RUINS AND WHITEWASHED BUILDINGS. I WAS NOT PREPARED FOR THE DOMINANCE OF BYZANTINE ART AND ARCHITECTURE, THE OMNIPRESENCE OF ICONS, THE CHURCHES IN THE ROCK CLEFTS. THE UNYIELDING GRANDEUR AND HARSH MONUMENTALITY OF THE SOUTHERN PELOPONNESE, ESPECIALLY OF THE MANI PENINSULA, BECAME EMBLEMATIC OF GREECE, CHALLENGING ME TO WORK MORE DIRECTLY AND IMMEDIATELY. THE EYE ENCOMPASSED SO MUCH AT A GLANCE THAT IT WAS IN APPROACHING THE FLOW OF LIGHT AND COLOR RATHER THAN GRASPING THE SPECIFIC FORM THAT I BEGAN TO CAPTURE THE VIVIDNESS AND CLARITY OF THE LAND AND ATMOSPHERE.

ALL THIS COMING AND GOING REQUIRED INNUMERABLE DRIVES TO AND FROM THE ATHENS AIRPORT. IN GENERAL, IT DOESN'T MATTER WHETHER I GET LOST, BECAUSE THERE IS ALWAYS SOMETHING TO DRAW. WHEN I AM

TRYING TO CATCH A PLANE, HOWEVER, IT DOES MATTER. IN ATHENS I MISSED TWO. I HAVE SEEN MORE OF THE BACK STREETS OF PIREAUS, THE SMALL CITY NEIGHBORING ATHENS, AND OF ATHENS ITSELF THAN ANYONE WOULD DESIRE, MAPS BEING USELESS. BUT PIREAUS IS GLORIOUS ON A SUMMER NIGHT IF YOU FOLLOW THE SHORE, THE STRINGS OF LIGHTS OF THE SHIPS AND CAFÉS SPARKLING ON THE WATER, THE AIR FILLED WITH THE SENSE OF ARRIVAL AND DEPARTURE, MOVEMENT AND REPOSE. AND THE BEAUTY OF THE PORT OF ATHENS AT TWILIGHT, THE VIOLET SILHOUETTES OF FREIGHTERS AND TANKERS LOOMING IN THE GILDED PINK HAZE AMONG THE SMUDGES OF ISLETS, IN COMBINATION WITH THE THROB OF INTERNATIONAL COMMERCE, WAS IRRESISTIBLE AND MADE ME TAKE THE RISK OF STOPPING TO DRAW.

AFTER A COLD CHRISTMAS IN GREECE, I PLUNGED INTO TURKEY, AND IT WAS A REVELATION. FOR THE FIRST FIVE DAYS I WAS IN ISTANBUL, THE LIGHT REMAINED THE SAME FROM MORNING UNTIL NIGHT. A MURKY BLUE GRAY MIST PENETRATED THE CITY. BLACK CROWS PERCHED IN THE LEAFLESS TREES. A TANGLE OF STREETS RISING AND FALLING ABRUPTLY, CUT BY STEEP FLIGHTS OF STEPS ONCE AGAIN MADE MAPS IRRELEVANT. TO PAUSE TO DRAW WAS AN INVITATION TO CONVERSATION. UNPAINTED WOODEN BUILDINGS WEATHERED TO A BLACKISH BURNT UMBER LINED

ALLEYS WHERE MEN SWINGING DOMED BRASS TEA TRAYS SUSPENDED FROM RINGS THEY HELD IN THEIR HANDS CIRCULATED FROM CAFÉ TO OFFICE. ALL DAY LONG CRIES OF RIGHT! RIGHT! RIGHT! STOP! LEFT! LEFT! LEFT! STOP! ECHOED IN THE STREETS. I ASSUMED IT WAS THE STREET VENDORS. IT WAS NOT UNTIL I PICKED UP A RENTAL CAR AND TRIED TO NEGOTIATE THE EXCRUCIATINGLY NARROW STREETS THAT I DISCOVERED THE TRUTH. TURNING CORNERS REQUIRES A COMMITTEE OF ADVISORS TO JUDGE THE DEGREE OF BACKING AND FILLING. THERE IS NOTHING LIKE THE THRILL OF ACCOMPLISHMENT IN NAVIGATING FOREIGN TRAFFIC SUCCESSFULLY.

DRIVING OUT OF ISTANBUL TOWARD BURSA PAST MILES AND MILES OF SHANTY TOWNS LED ME INTO ONE OF THE GREENEST LANDSCAPES I HAVE EVER SEEN, WHICH ONE WEEK LATER WAS COVERED IN SNOW. THE UNDULATING HILLS WITH ROWS UPON ROWS OF IVORY BIRCH TREES, THE DEEP RED SOIL, THE THATCHED HUTS BUILT AT THE BASES OF ANCIENT TREES MARK THE INTIMATE SCALE OF THE COUNTRYSIDE. THE CONVERGENCE OF TAXIS, DOLMUSES (SHARED TAXIS), BUSES, TRUCKS, HORSE-DRAWN CARTS, MOTORCYCLES, OFTEN HERDS OF SHEEP AND GOATS, CLOUDS OF DUST AND EXHAUST INDICATES YOU'VE REACHED TOWN. FOLLOWING THE MAP TO TAKE THE MOST DIRECT ROUTE FROM BURSA TO BERGAMA, I CAME FACE TO FACE WITH

A BULL, AS SURPRISED AS I WAS, ON A DEAD-END MUD ROAD, HAVING MISSED AN UNMARKED TURN. BACKTRACKING, WITH NIGHT HAVING FALLEN, I FOUND MYSELF ON A SNOWY MOUNTAIN ROAD IN SUCH THICK FOG THAT I EXTINGUISHED MY LIGHTS TO SEE IF THAT WOULD IMPROVE THINGS. IT DIDN'T. MY ONLY CONNECTION WITH THE HUMAN WORLD WAS A SET OF HEADLIGHTS ABOUT EIGHT KILOMETERS AHEAD THAT WOULD FLASH INTO VIEW EVERY TEN MINUTES. COGNAC AND NESCAFÉ WERE A WELCOME SIGHT AT BREAKFAST AND I EXAGGERATE ONLY SLIGHTLY IN OBSERVING THAT THE DINING ROOM WAS SO COLD YOU COULD HAVE CUT THE HONEY WITH A KNIFE.

IT WAS DIFFICULT TO FIND HEAT AND HOT WATER AT THE SAME TIME SO WHEN I ARRIVED IN IZMIR ON THE NORTH AEGEAN COAST I DECIDED TO SURRENDER AND STAY IN THE HILTON. SINCE I KNEW IT WAS THE TALLEST BUILDING IN THE CITY, I THOUGHT I COULD FIND IT. ALTHOUGH I COULD SEE IT STANDING BY THE SHORE AND ENVISION TORRENTS OF HOT WATER, I WAS CAUGHT IN A MAZE OF INTER-SECTING ON- AND OFF- RAMPS THAT CARRIED ME BEYOND "IZMIR BIDS YOU FAREWELL" BEFORE I KNEW WHAT HAPPENED. IT WAS ANOTHER HOUR BEFORE I CHECKED INTO THE HOTEL, AND YET ANOTHER HOUR BEFORE I GOT THAT HOT SHOWER: THE FRONT DESK HAD TO SEND UP A HANDYMAN TO WRENCH THE HOT

WATER FAUCET INTO A WORKING POSITION. THE FOLLOWING NIGHT, AGAIN SEARCHING FOR SUITABLE LODGING, AND HAVING DECLINED VARIOUS OFFERS, I SPOTTED AN ORANGE NEON "CASINO" SIGN ON THE HORIZON ATOP A MODERN HIGH-RISE HOTEL. THIS, I THOUGHT, MUST GUARANTEE HOT WATER. BUT, BEING SKEPTICAL, I ASKED THE BELLBOY SHOWING ME A ROOM TO CHECK THE HOT WATER. HE LED ME INTO A LARGE BLACK BATHROOM WITH A SUNKEN TUB AND TURNED ON THE TAP. HE COULDN'T TURN IT OFF. HAVING EXHAUSTED THE LOCAL POSSIBILITIES, I GAVE IN, AND ONCE MORE IT WAS TEPID WATER, FEEBLE HEAT AND DINING IN MY SHEEPSKIN COAT WITH ONE HAND IN MY POCKET. BUT IT WAS WINTER AND TRAVELERS WERE FEW. THE REPUTATION OF THE TURKISH FOR WARMTH AND HOSPITALITY IS WELL-DESERVED. I PARTICULARLY REMEMBER ONE MAN WHO CAME OUT OF HIS OFFICE TO HOLD AN UMBRELLA OVER ME AS I STOOD DRAWING IN THE RAIN.

MY WORK, WHICH ALLOWS ME TO GO WHEREVER I LIKE AND TO DRAW WHATEVER I WANT, IS PROFOUNDLY SATISFYING. THERE'S NOTHING BETTER. OVER THE LAST YEAR I HAVE SEEN SO MUCH THAT HAS CAPTIVATED AND DELIGHTED ME, THAT HAS MADE ME EXTEND MY THINKING TO EXPRESS MY VISUAL EXPERIENCE, THAT I SEE WITH NEW EYES.

Greece

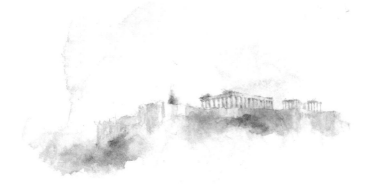

I walked up to the Acropolis early one morning through the quiet streets of the Plaka district, before the onslaught of midday heat, past olive trees glimmering in the light breeze. Confronted by the massive marble blocks, distracted by the light glaring off a stone path worn by centuries of foot traffic, it was difficult to experience the Parthenon as a symbol of western civilization. My attention was drawn rather to the Temple of Athena and the elegant, graceful caryatid columns. The fragments were tantalizing, but I preferred my first distant view of the Acropolis, isolated on its plateau above the center of the city, a glimpse at dawn through the narrow shuttered window of an old hotel, the sky a deep cobalt blue, the rose light of the sun beginning to reflect off the pale peach marble.

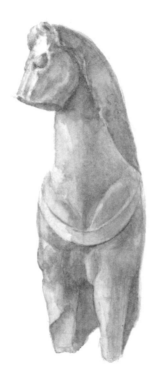

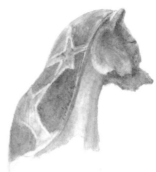

Fragments of sculpture from the Acropolis Museum

Lion from Delos.

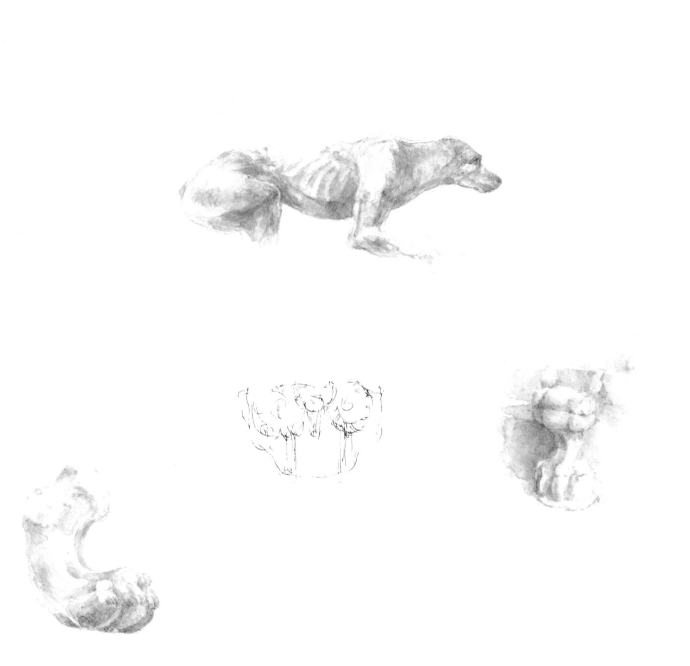

The Greeks have great dogs, especially German short hairs.

[color notes: burnt sienna, thalo green, cobalt blue.]

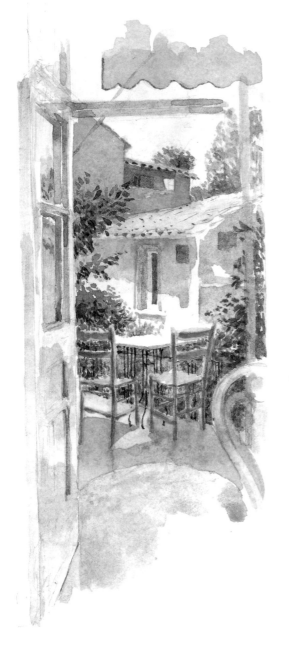

The streets, lined with ocher and ivory buildings covered with blood-red bougainvillea, were hot and empty. I walked into a café in the Plaka district for a Nescafé frappé, my main source of nourishment in Athens.

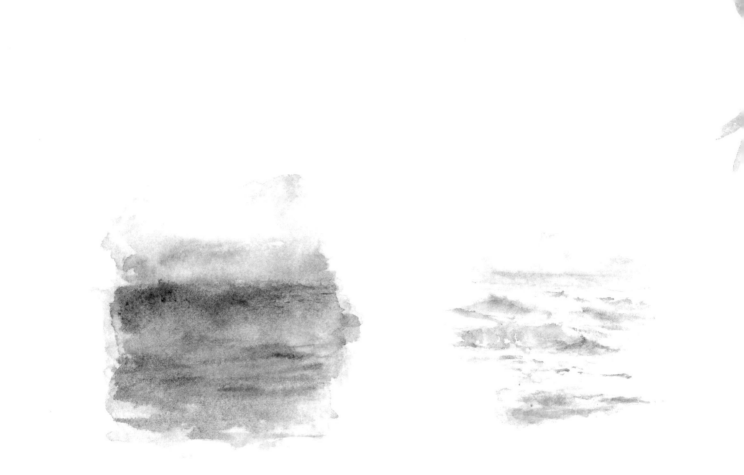

The color of the sea changed as the angle of the sun shifted.

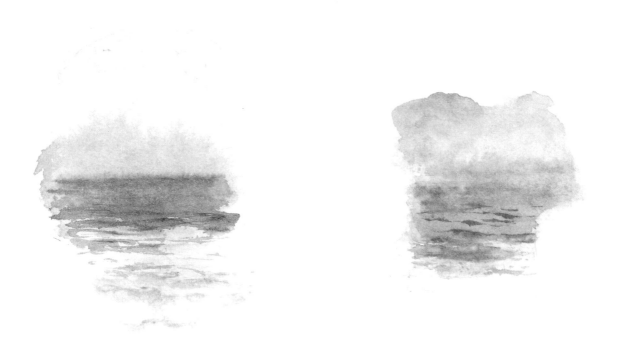

The remains of ancient stone walls shimmered beneath the shallow clear water.

Arrival in the port of Naxos at sunset. Gliding into a bath of
color, molten on the horizon, I half expected to feel the sensation
of color on my skin, in my mouth.

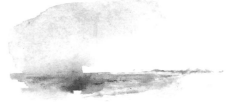

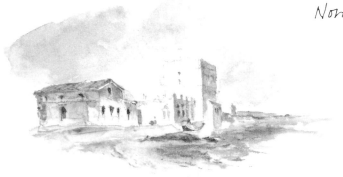

North side of Naxos. Midday.

Cats of every persuasion.

To begin to capture the
sensation of light, I had
to let go of the strict
appearance of things. It
was the play of color rather
than the grasp of the form
that was important. The
pinkness at dawn was so
intense, so enveloping, I
was conscious of it through
closed eyes, lingering on
the edge of sleep.

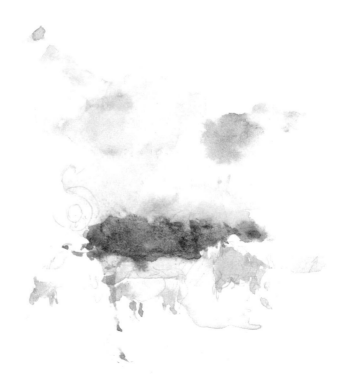

Monastery, early morning

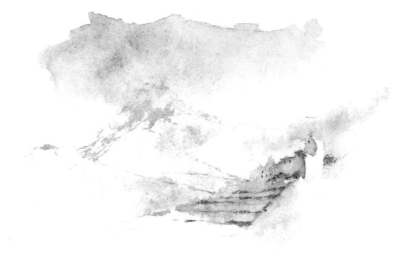

Mountains of watermelons were dumped on the sidewalks. The markets were shaded by awnings lined in contrasting color making the color of the cast shadow mysterious and surprising, a glow against the stark, brilliant whites of the buildings.

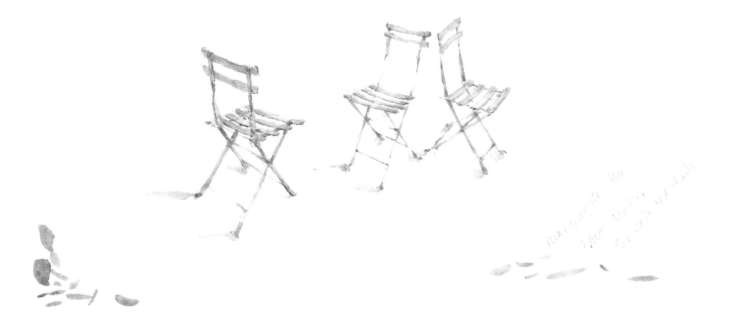

Seas of chairs dominate Greek towns.

Intrigued by its form and color, I walked by
this cedar for two weeks until one evening
when the blue-red light of the setting sun,
reflecting off the water, hit it, bringing
the color to its richest vibration. Then I
saw what to paint.

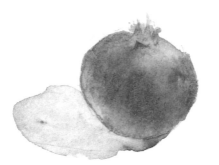

Pomegranate.

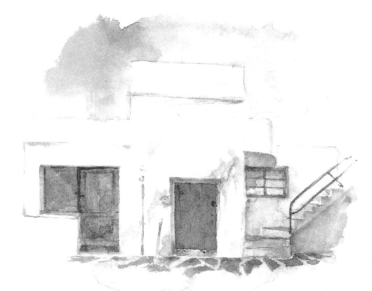

From the top of the Kastro, a medieval Venetian settlement, the narrow stepped streets spiral down to the sea, punctuated by ocean liner style buildings of the 'thirties.

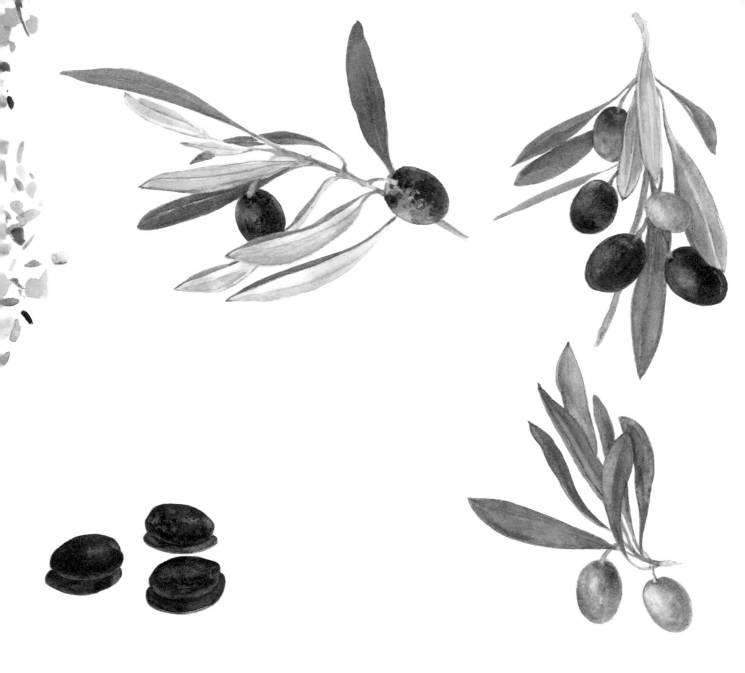

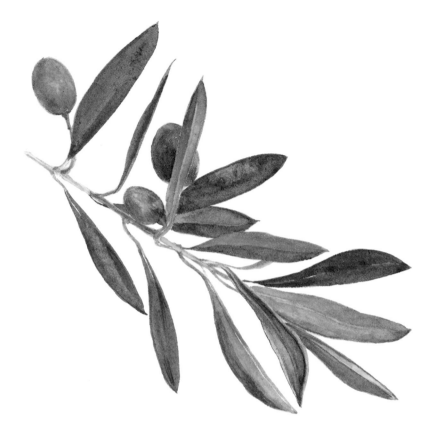

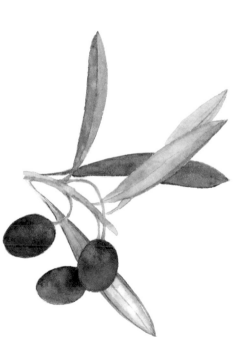

Olives from a tree in a grove outside AhKaladoKampos on
the edge of a valley east of Tripoli. Picked at the same
moment, in late October. Each olive was a little world of color.

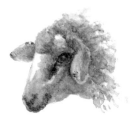
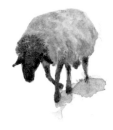
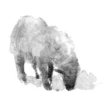

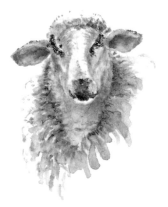

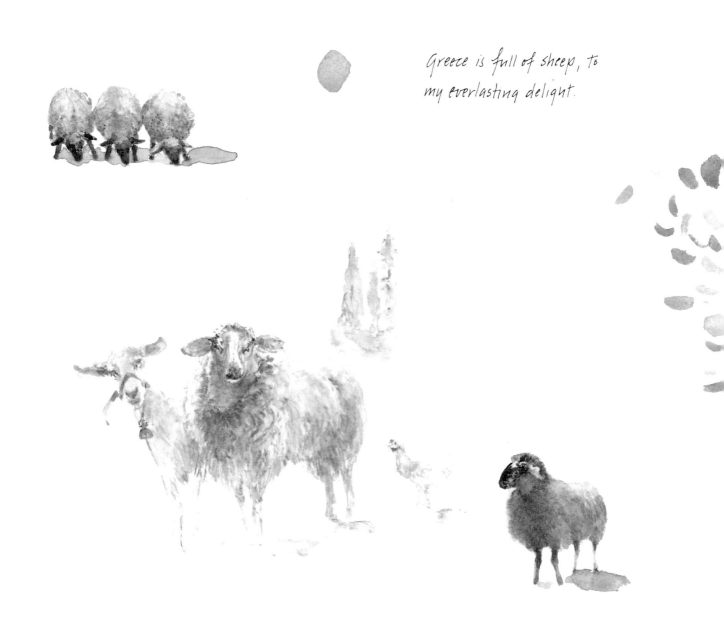

Greece is full of sheep, to my everlasting delight.

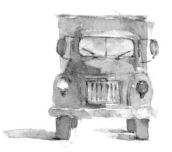

I admired the proportions of
an old Volvo truck, parked at a
gas station east of Tripoli.

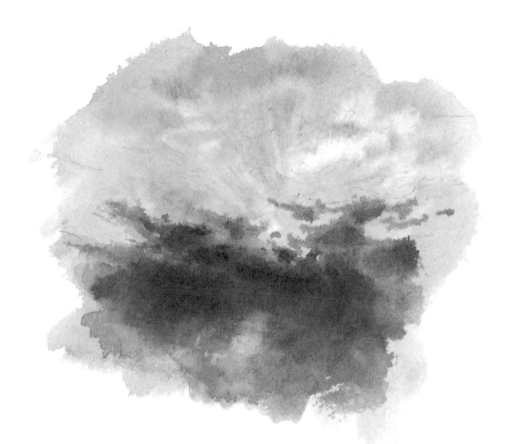

Moonlight on the Aegean. Southeast coast of the Peloponnese. Late October.

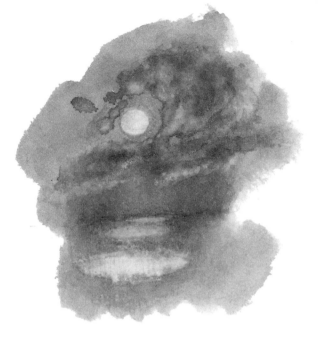

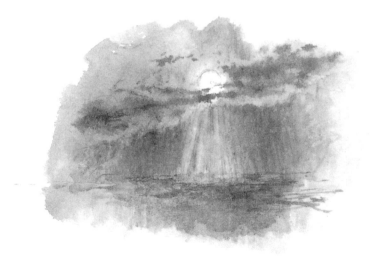

[color notes: raw umber, indigo,
viridian, Winsor violet.]

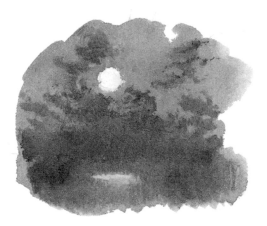

View from my balcony in the town of Githio. No
indication of the horizon. Fast moving indigo clouds.

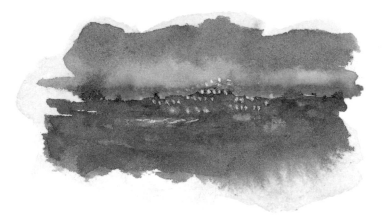

The ferries arrive and depart all night in summer, catering to the sybaritic impulse. The reflection of the lights lingered in the troughs of the shallow waves, drifting and sliding across the dark sea.

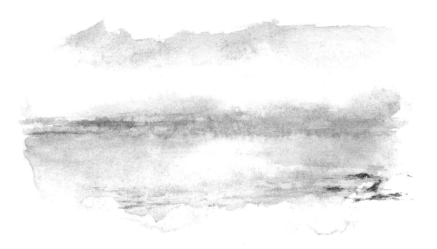

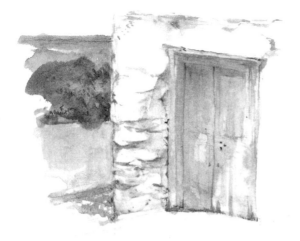

Naxos, late morning.

A compelling aroma emanated
from the gutter.

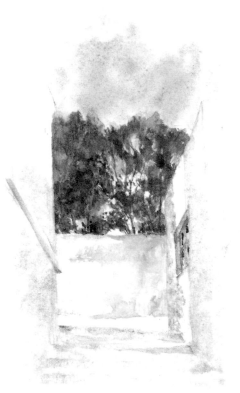

6:30 in the morning. My attention was caught by the
dense foliage framed by all the different whites. The impact
was austere, lush, abstract, all at once.

Brief notes made while driving into Naxos
from the countryside. Late afternoon, July.

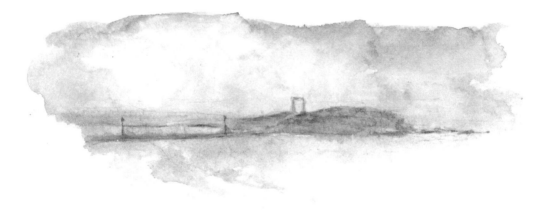

Portal for an unfinished Temple of Apollo on the diminutive
island of Palátia, linked to Naxos by a causeway.

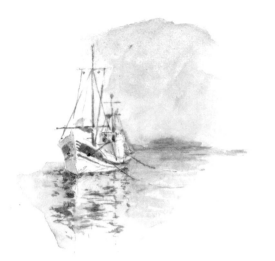

Naxos harbor. Paros in the distance.
Early evening.

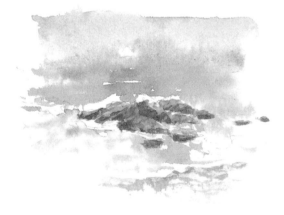

Grotta, on the northside of Naxos.

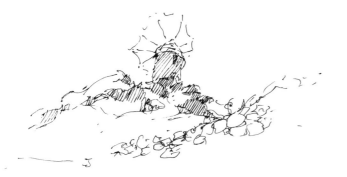

The colors of the landscape
were muted by the summer
light and dryness: umber,
terre verte, pale ocher. The
olive trees on Naxos are
more yellow, less silvery.

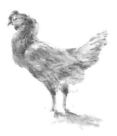

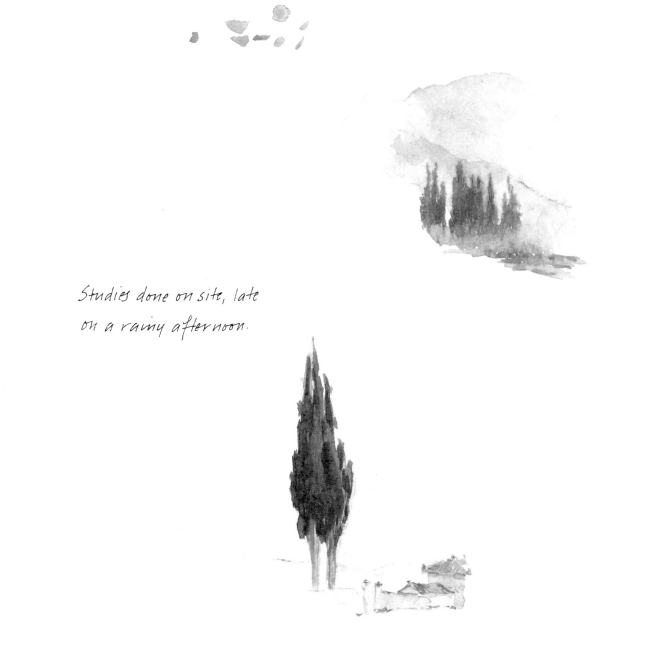

Studies done on site, late
on a rainy afternoon.

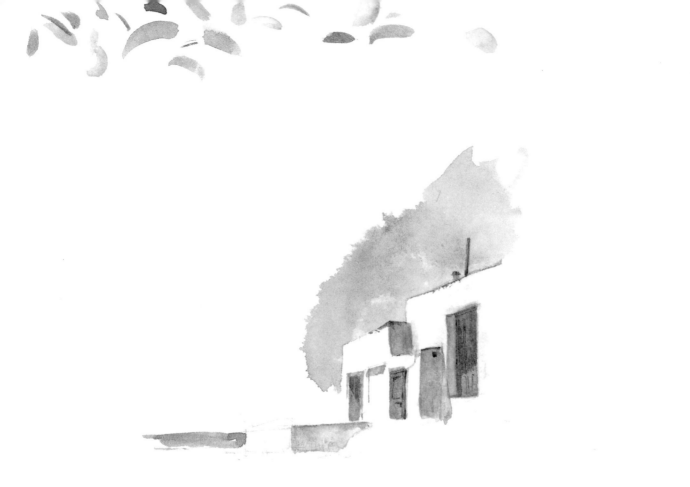

Noon. The doors echo the color of the sea. The depth of the greens in the shadows.

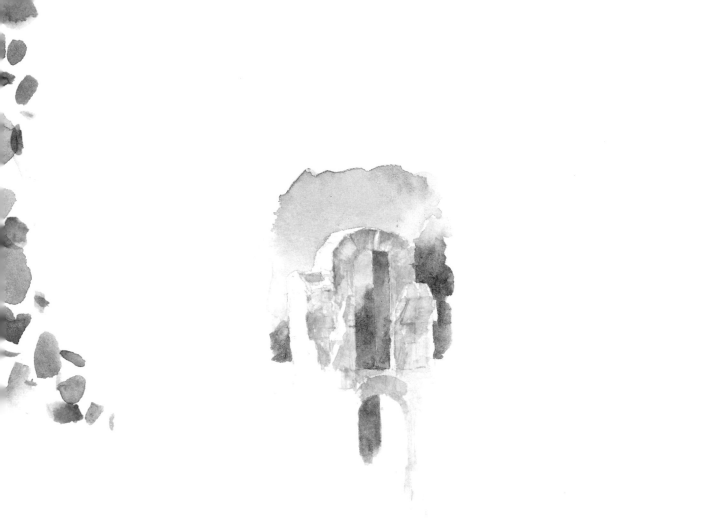

Very early morning. Brilliant blue shadows. The contrast of the
creamy pink stone against the vibrant green hillside in the near distance.

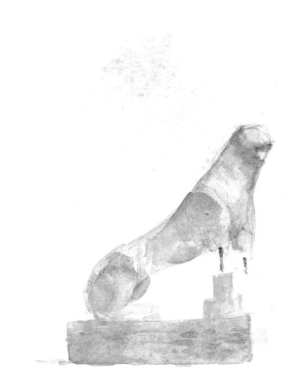

Lion from the Lion Terrace on
Delos, a flat strip of pale rocky
earth emerging from a gleaming
blue sea. Silent, except for
the croaking of frogs. Dozens
of spider webs spun among the
ruins, shimmering in the intense
white light of noon.

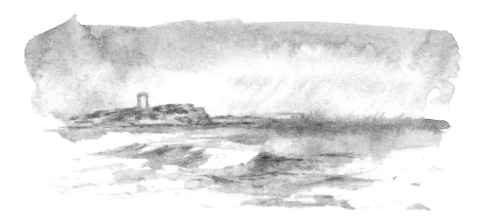

Palátia, about 1 p.m.

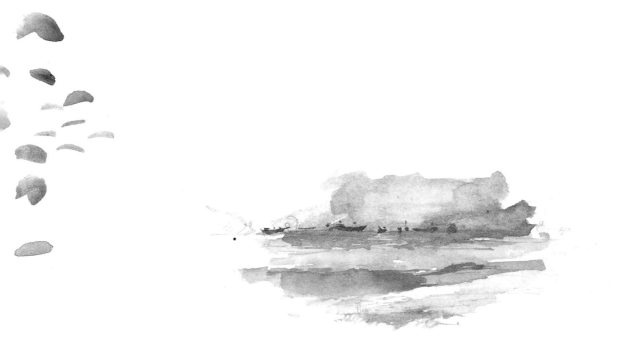

Loading the cargo ships at Nafplio.
Late afternoon. December. Study.

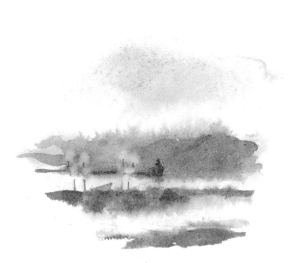

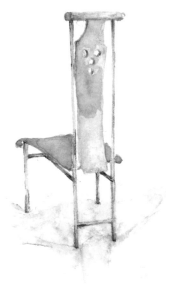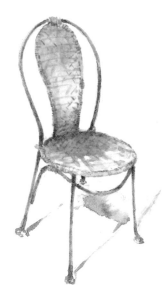

Enamel house numbers.

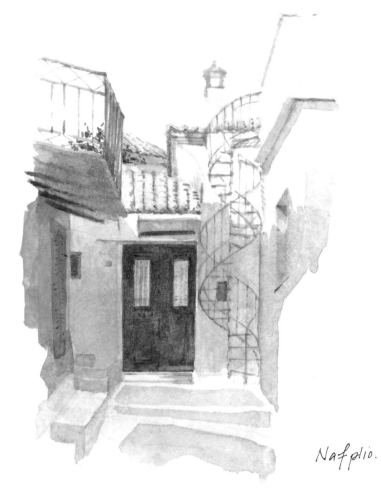

Nafplio.

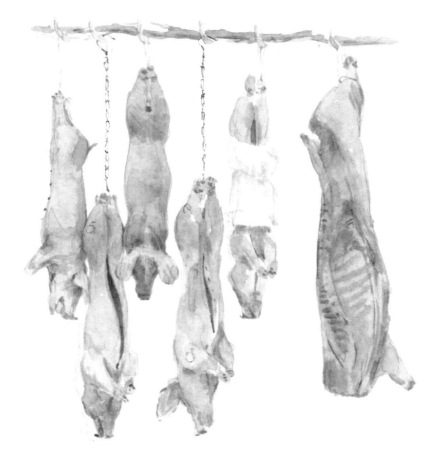

Pigs hanging outside a butcher shop in Nafplio, the day before
Christmas. Across the street were orange trees heavy with fruit.

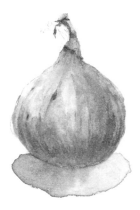

The swelling and sagging of the form, the rich
color and the slightly translucent skin make figs,
apparently simple, a provocative subject to study.

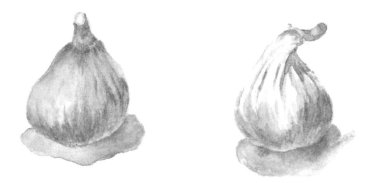

Study done over lunch in Tiros, a town south
of Nafplio, in a little café by the water.

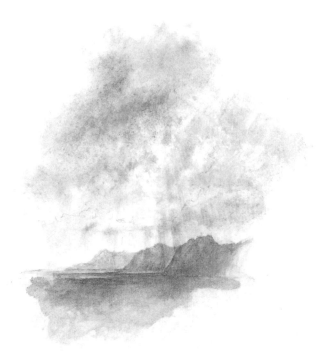

View to the northwest from a café terrace in Ia on Santorini. Mid-October.
The town was pleasantly deserted. 'Sixties jazz, Brubeck to be specific,
played in the background. I could simply sit and watch the light change,
the villages on Thirassia emerging and dissolving in the shifting clouds.

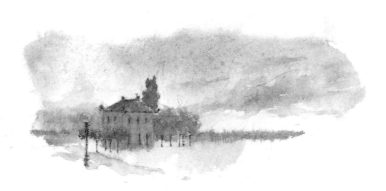

Driving back from Monemvassia to Githio, I decided to follow the
setting sun; it was so pretty shining through the dark olive trees
beneath an overcast sky. When I got to Plitra on the coast,
the sun was disappearing.

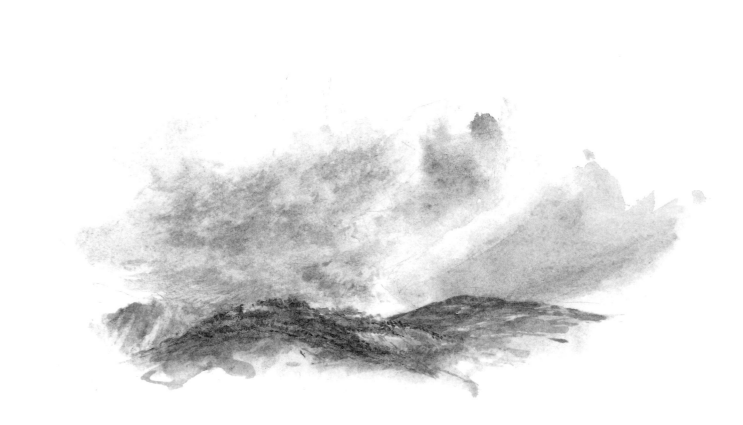

Late December. On a side road to Ahkaladokampos, east of Tripoli.
The wind of the approaching storm shook the car as I drew.

North of Paralla Tirou, on the east coast of the
Peloponnese. Mid-October, about 4 p.m.

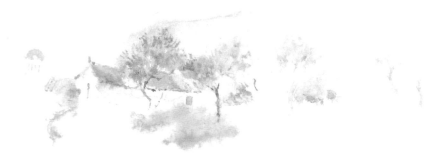

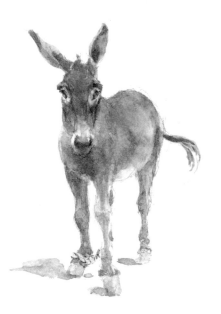

Hobbled donkey.

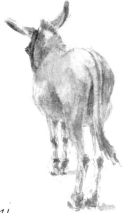

Contemplative donkey in Ia, Santorini.

My first glimpse of Limeni was from the high coast road, looking down between the cypresses to the aquamarine water. Once again the town was deserted because it was early November, but still deliciously warm. At night one could lie on the stones of ruined Byzantine churches, lapped by the sea, gaze into the sky teeming with stars and then slip into the dark sea for a swim.

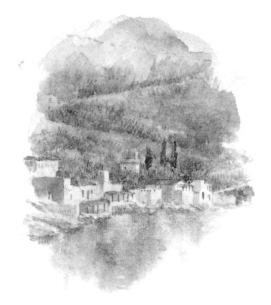

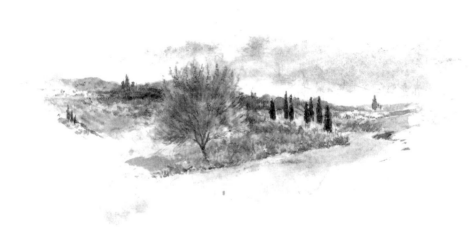

Along the Messenian Gulf Road, southwest Peloponnese.

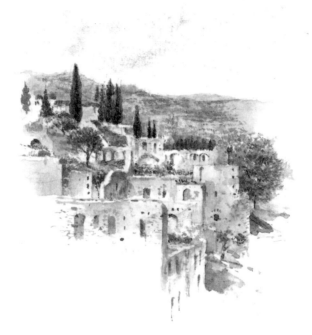

Mystra, a ruined Byzantine city of pink stone. Near Sparta. Late fall.

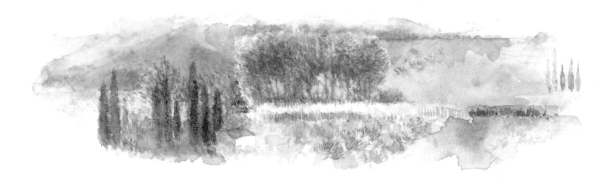

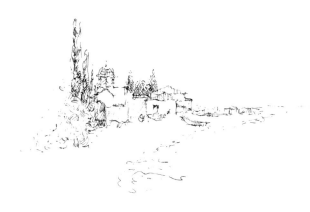

Byzantine church on the beach.

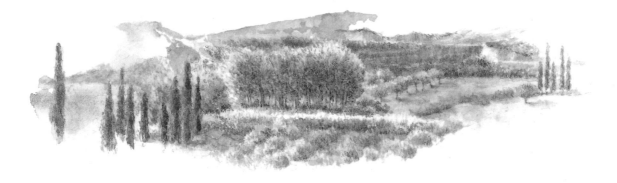

I drove around a bend in a curving potholed dirt road heading toward the coast and was immediately struck by the sight of a copse of trees whose turning leaves, wet from a recent storm, glimmered in the morning sun. The color of the earth was a deep rose sienna. Cows grazed in a neighboring field. The beach, Skoutari, for me the most perfect in the Peloponneso, was completely deserted. Late October, beautifully warm.

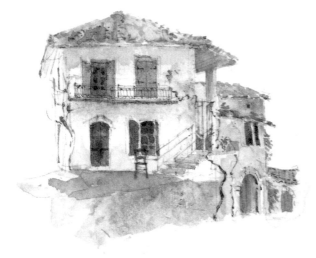

All the shades of blue in the cool blue-gray twilight.

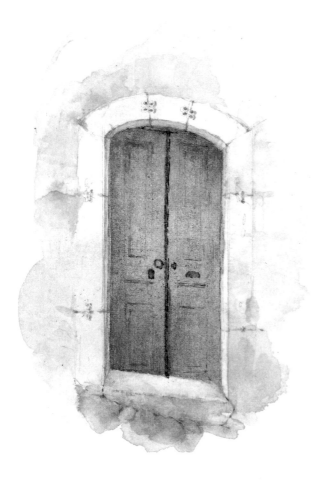

Stemnitsa, a small village in the
mountains near Tripoli. Late afternoon,
December. Terrifically cold and windy.
Black ice on the unbanked roads. Aroma
of roasting meat in the air. Walking
up the narrow cobbled streets in the
dim light, the atmosphere felt
hauntingly medieval.

South of Stemnitsa. Sunset.

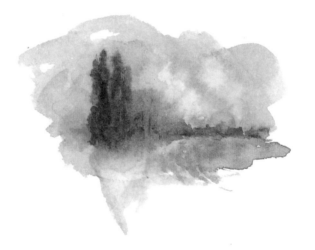

The vapor rising from the garishly painted discos
along the coast near Nafplio merging with the fog
at nightfall caught my attention.

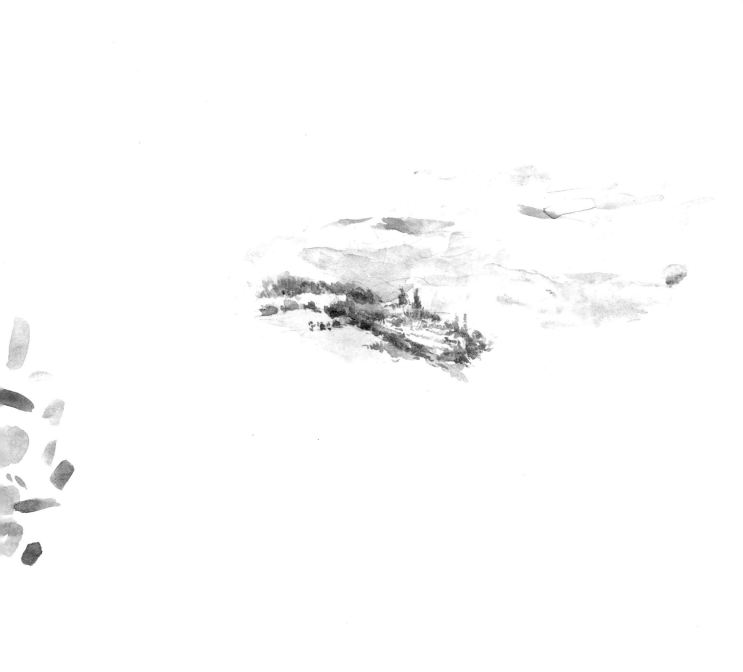

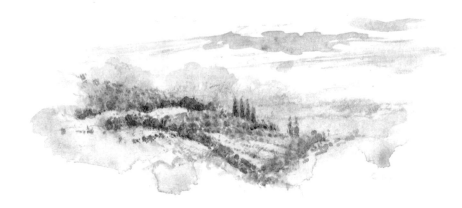

It was a pleasure to see the weather come in and watch the colors
of the landscape change. At this moment I was particularly
intrigued by the darkness of the sky against the pale earth,
the pale salmon pink tint of the clouds. Outside Ahkaladokampos,
looking south, at the end of December around 4 p.m.

Detail of curved building, Dhimitsena.

A cocker spaniel so beautifully combed
that when he sat, he looked molten.

A regular by the harbor in Nafplio.

Afghan puppy looking for his playmate.

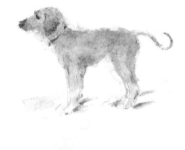

Mischievous nutria.

The severest, most desolate part of
the Peloponnese, the Mani
Peninsula. Everything is of stone,
crumbling but enduring.
It was at this point, under the

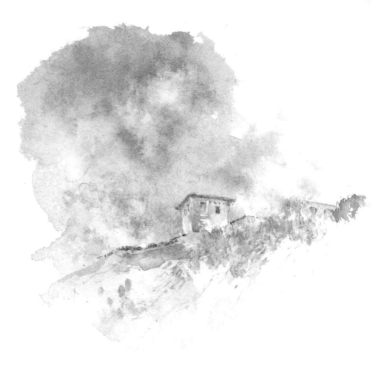

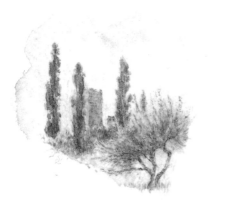

influence of a friend from
Sparta that I began to indulge
in the classic Greek breakfast:
ouzo and Nescafé.

Brilliant white clouds drifted over the
austere granite-gray and red-violet
mountains. Cactus crowded against the
stone walls and ruined towers.

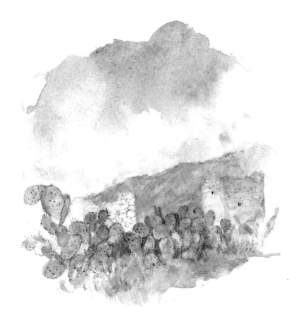

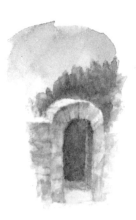

[color notes: yellow ocher, naples yellow,
cerulean blue, Winsor green, burnt umber.]

Stones from a beach in Pórto Héli, across from the island of Spetses.

Greek amphitheater with Roman additions, next to
a tire yard in Argos. Afternoon, late fall.

Turkey

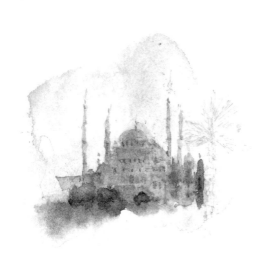

I stayed in the European section
of Istanbul, north of the Golden
Horn and the Sultanahmet.
Rainy Sunday morning.

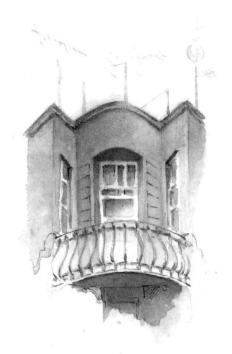

I found the curved and indented corners of buildings
and the tall narrow doors particularly intriguing. This is
a view to the northwest from my hotel room.

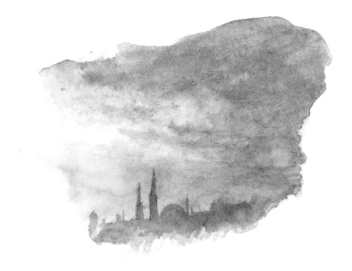

Winter twilight. The sky was always suffused with pink near the horizon.

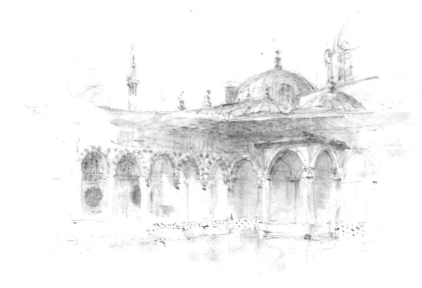

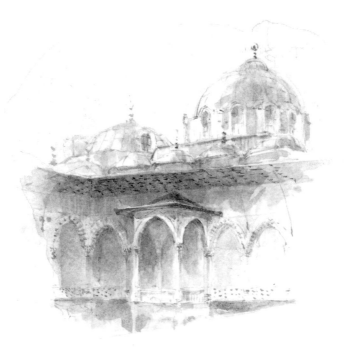

The Harem, Topkapi Palace. Winter, in the rain.

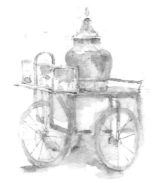

Wheeled teacarts are everywhere in the steep, twisting streets.

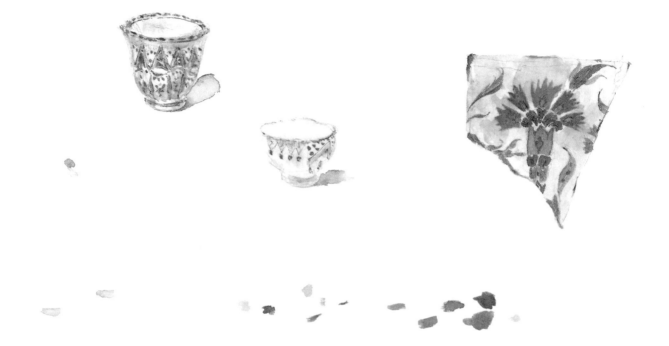

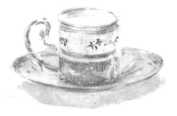

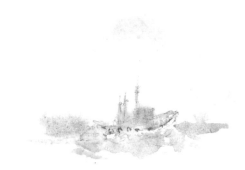

I was drawing by the Bosphorus, near Dolambache Palace, looking across to the Asian side of Istanbul, watching the boats dip and surge in the billowing water. Sunny, windy day. Cascades of spray and waves crashed over the sea walls.

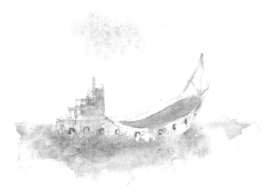

Looking west toward the Sultanahmet. 3:30 p.m., January.

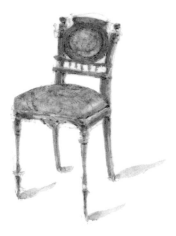

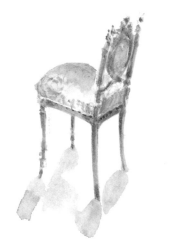

Dolambache Palace. An astounding array of ornate, late-nineteenth-century chairs.

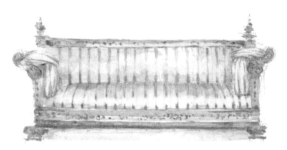

Couch in the Imperial Hall. The Harem, Topkapi.

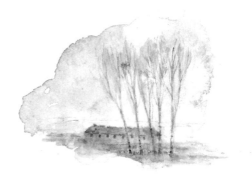

Driving through the winter landscape toward
Burga, I made these quick notes with my
sketchbook balanced against the steering wheel.

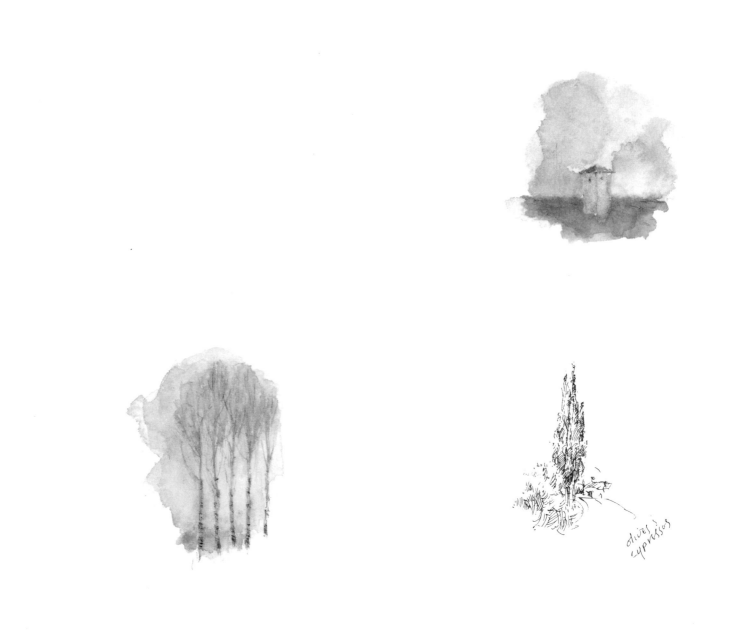

diversi
cypressos

In the vast green landscape there are towns of ocher, raw sienna, and rough gray stone, bleak in winter. But the colors of the houses at the base of Pergamon, an ancient Greek settlement above Bergama, are deliciously, startingly bright. The cobblestone streets reflect the light of the cold blue-gray winter skies and the barren trees, black from the rain, serve to intensify the impact. You come across houses, unoccupied, in disrepair, the rich colors of the interiors (cobalt blue, emerald green, ruby red) exposed through shattered windows.

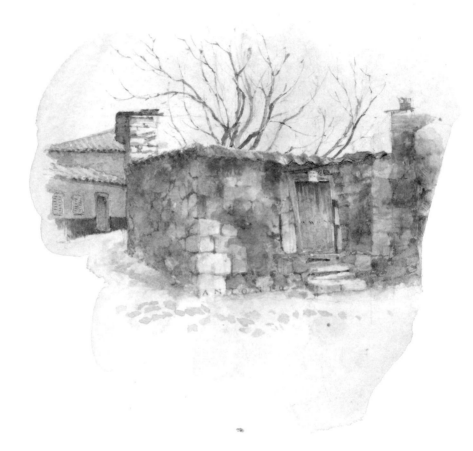

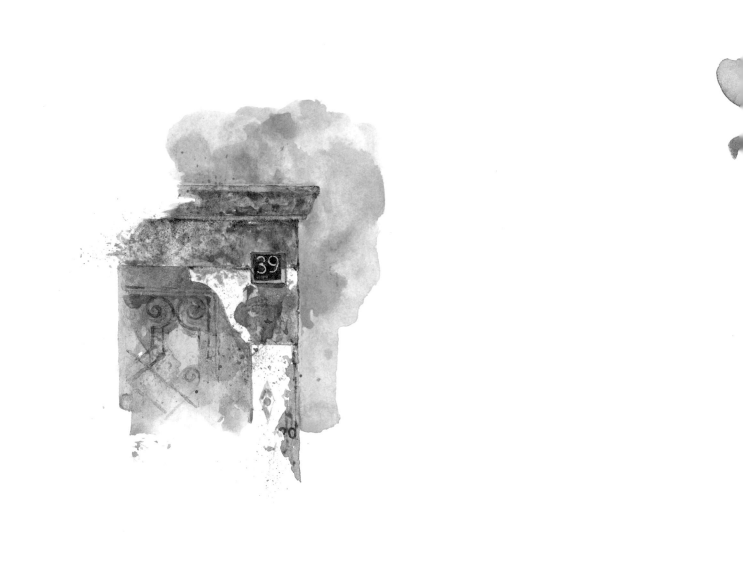

A chicken couple clearly in the midst
of a dispute, paused briefly when they
noticed I was drawing them.

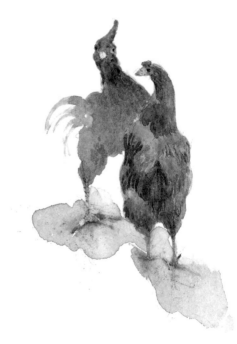

Denizens of the aviary at Dolambache Palace, where the bird keeper invited me to join him for red tea and cookies.

GÜMÜS
SÜLÜN

F I Z A N
T A V U Ğ U

There's a dog asleep in the
back of this Skoda truck.

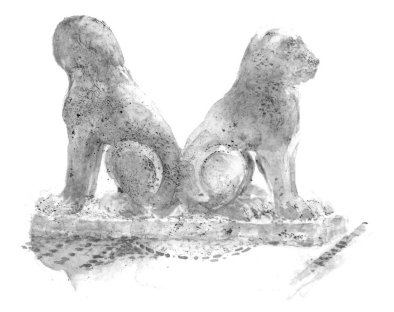

Lions at Ancient Sardis, east of Izmir

Nightfall at Sardis. Studies done on site,
trying to capture the last light.

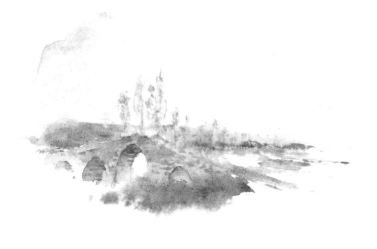

Ottoman bridge outside Assos, a village of stone on the northwest coast of Turkey, where Plato spent some time.

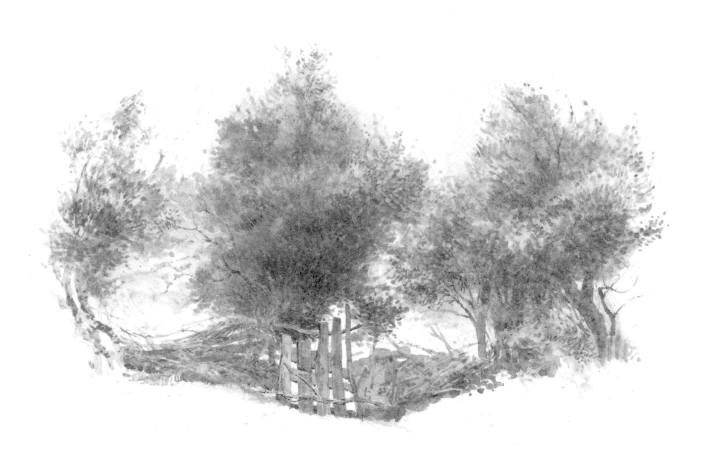

Sheep grazed in a stick fenced field on the road to Assos.

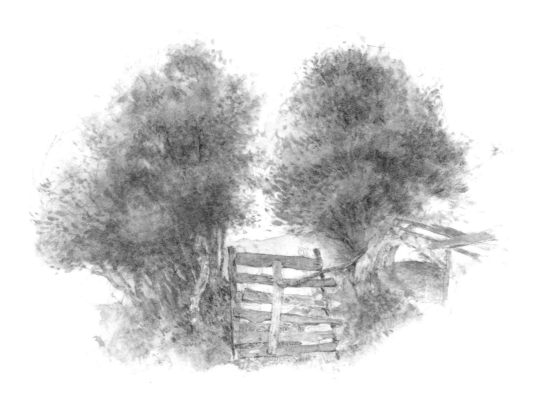

Across the lane.

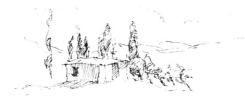

A few kilometers south of Edremit, on the coast.
Snow on the mountain tops.

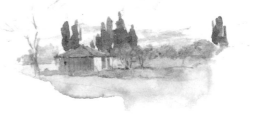

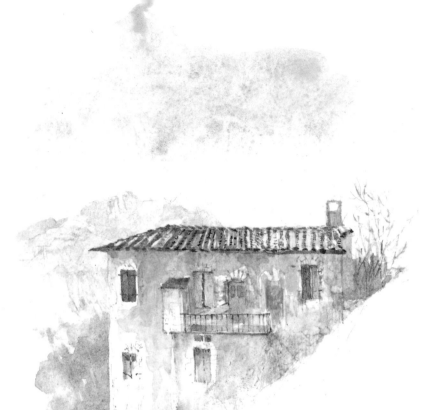

The contrast of the salmon pink building
against the cold blue mountain sky captured
me immediately. As I drove around a hairpin
curve where the village was clustered I saw
the valley drop away into the deep shadows
of late afternoon.

[color notes: indigo, Indian red,
 burnt sienna, yellow ocher.]

[color notes: brilliant turquoise,
 manganese blue, venetian red,
 raw sienna, aureolin.]

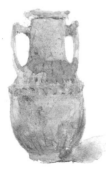

Seventh-century vessel.

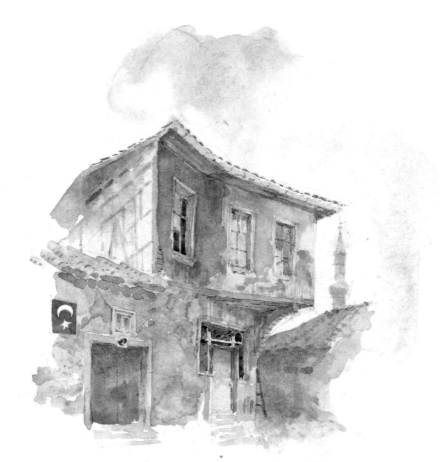

Bursa. You walk down utterly delapidated streets and then come upon lavish explosions of color.

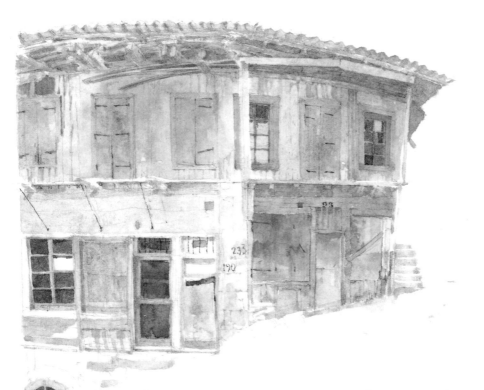

In a mountain village, I walked up a winding alley lined with
pale green façades and found this exotic curved building
at the top, composed of rough, silvery timbers.

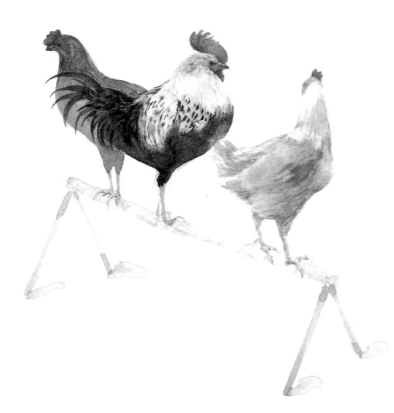

Dolambache Palace Aviary.

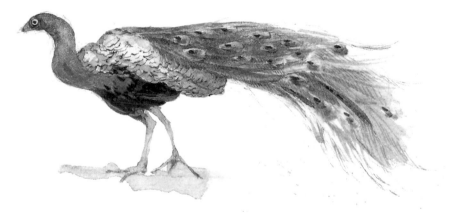

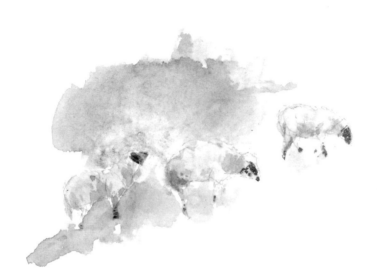

Sheep grazing in the sun, snowstorm approaching.

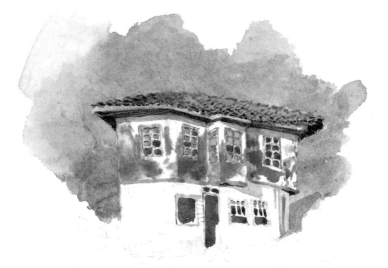

The deep steel-gray of the sky, indicating the coming
storm, made a stark contrast with the brilliant sunlight
reflecting off an abandoned house. About 1 p.m., winter.

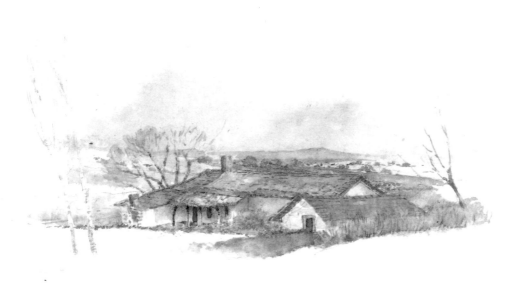

Long, low farmhouse nestled in green fields.
Lines of elegant birch trees.

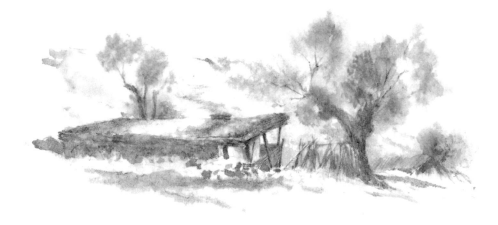

As I drove by, a shepherd looked at me as though I were crazy. This of course was not unusual, women drivers being so rare outside the cities. But he was right, a little farther along the road, I had to turn back because of a snowstorm.

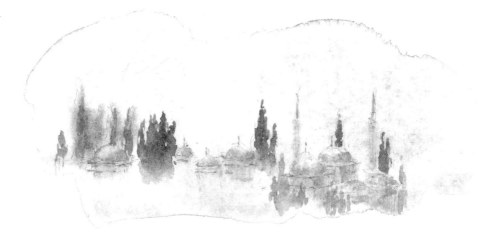

The streets of Bursa zigzag back and forth along the side of
a mountain on the edge of a cultivated plain. The skyline
is dominated by mosques and minarets. About 1 p.m., January.

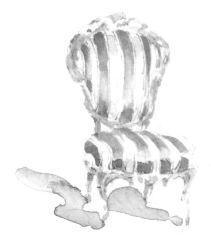

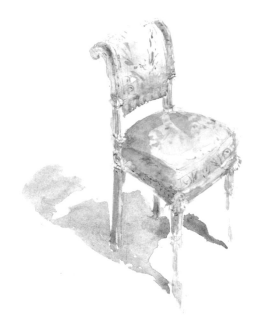

A few more of the limitless agglomeration
of chairs at Dolambache Palace.

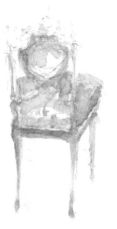

I glimpsed this chair in the window of a shop
in Istanbul, but because of the unrelenting
enthusiasm of the owner, I had to escape; I
stepped into an alley to make a note of what
I could remember of its elegant shape.

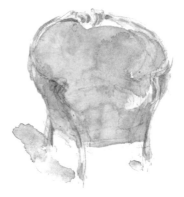

Taksim square, in the European
section of Istanbul.

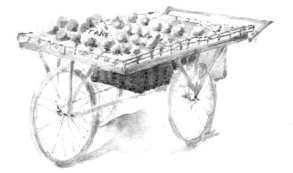

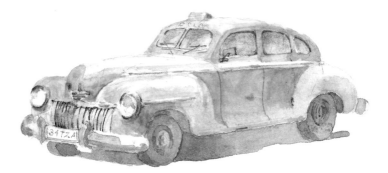

Lots of vintage cars, kept in perfect repair by
innumerable garages crowding the backstreets.

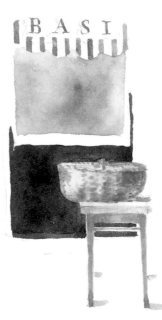

Walking through the extensive market streets of Bursa,
filled with shops and open-air stalls, put me in a trance.
There was so much, so fast: colors, textures, products
endlessly repeated in different configurations.

Bread is everywhere and it's delicious.

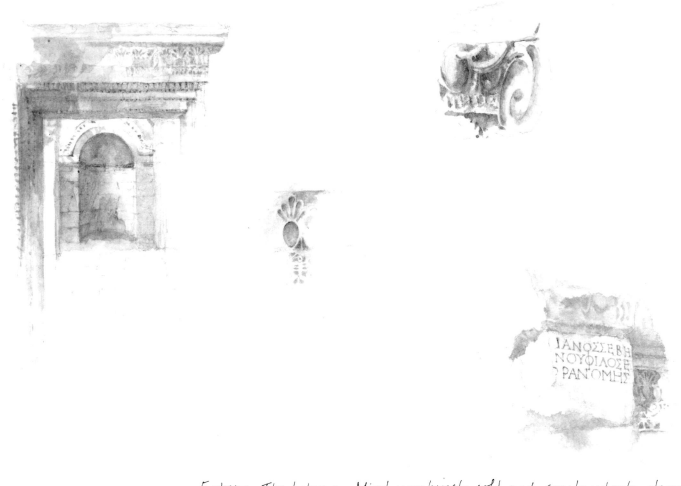

Ephesus. The Library. Mind-numbingly cold and spectacularly clear.
Late morning.

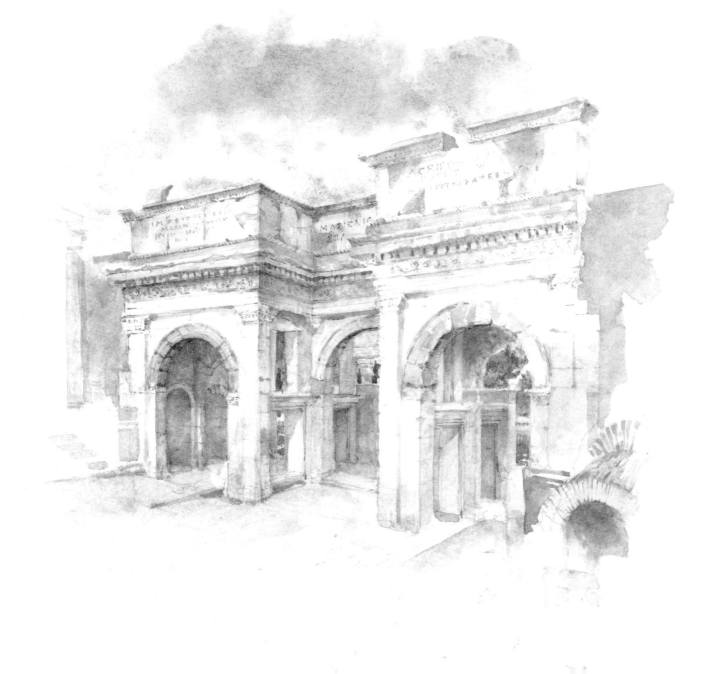

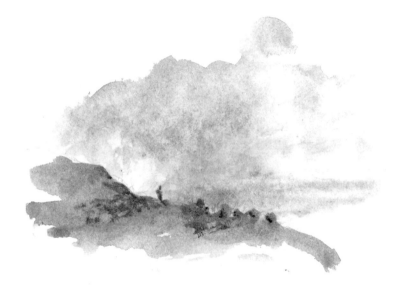

Evening, near Denizli, about 3 hours east of Izmir.

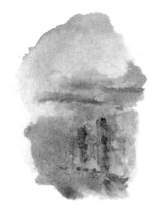

Nightfall looking over the valley.

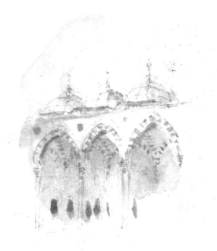

The Blue Mosque.

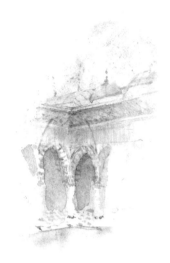

TopKapi.

Ferry on the Bosphorus.

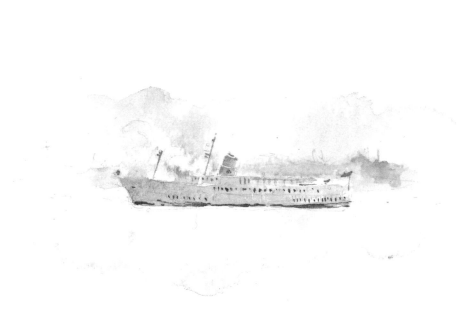

Ferry on the Golden Horn.

The inescapable, irresistible sea. The visual
impact of colorful little boats buoyed up by
glimmering liquid reflected light is a source
of enduring fascination.